LET'S START HAVING FUN.

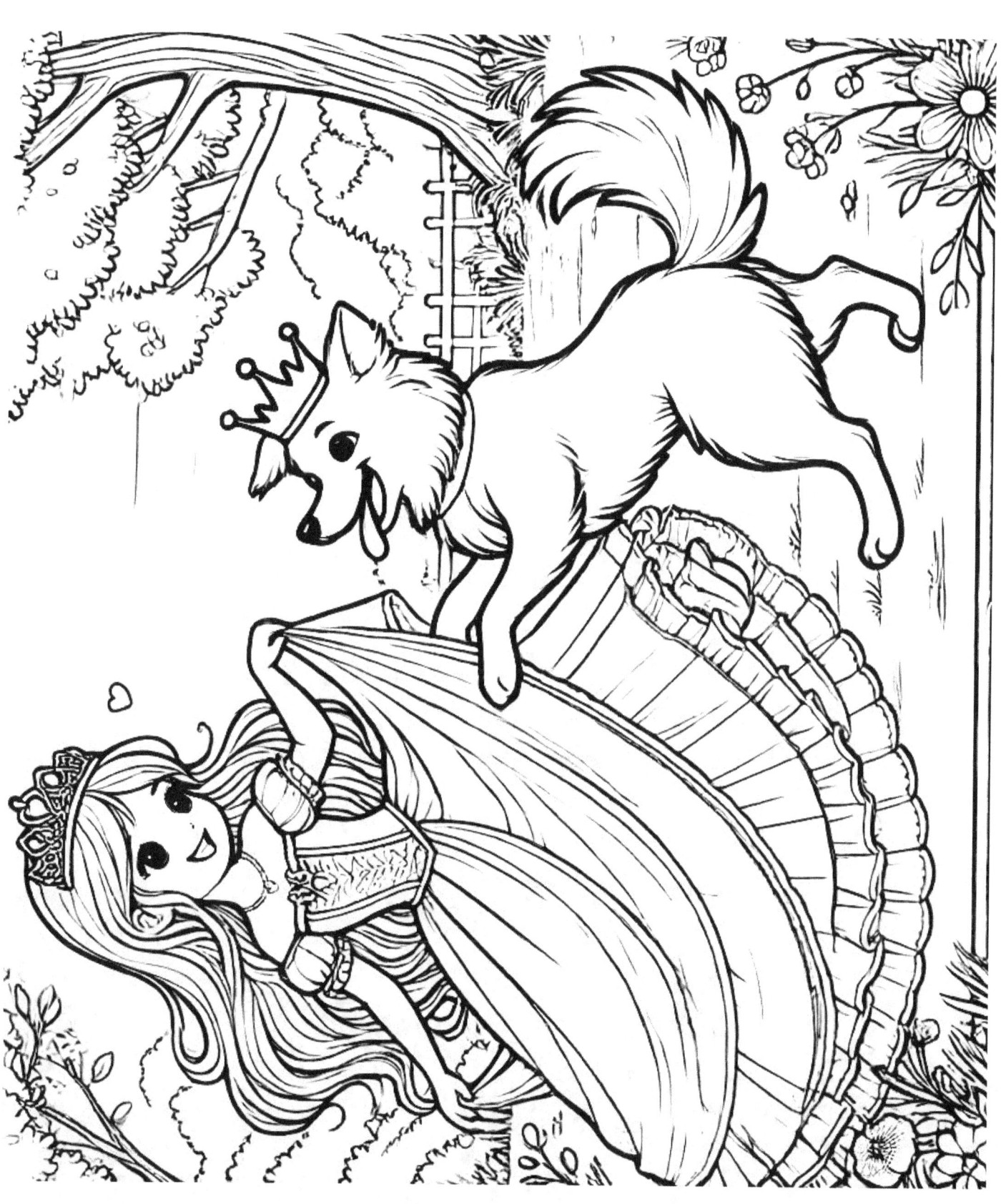

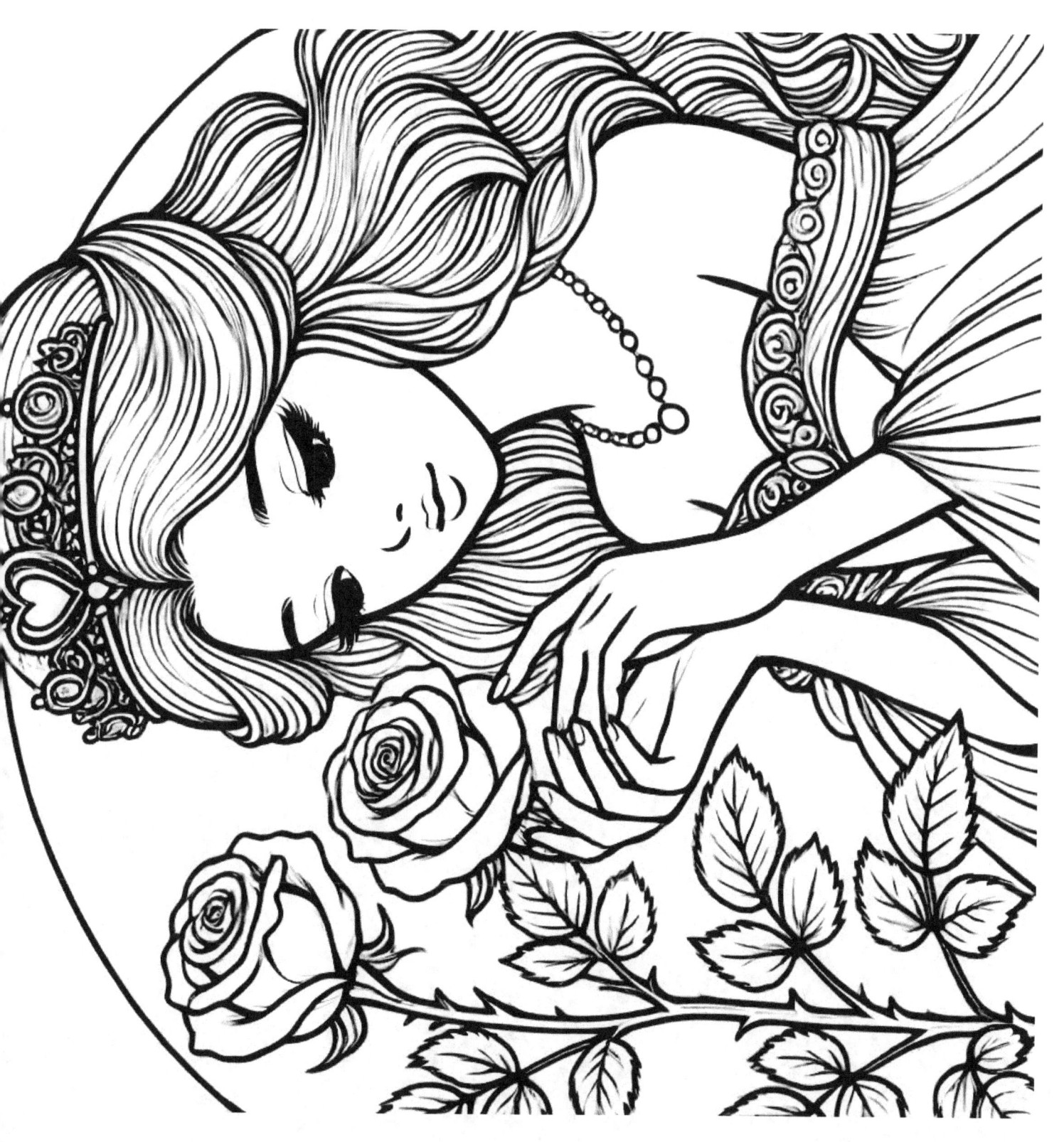

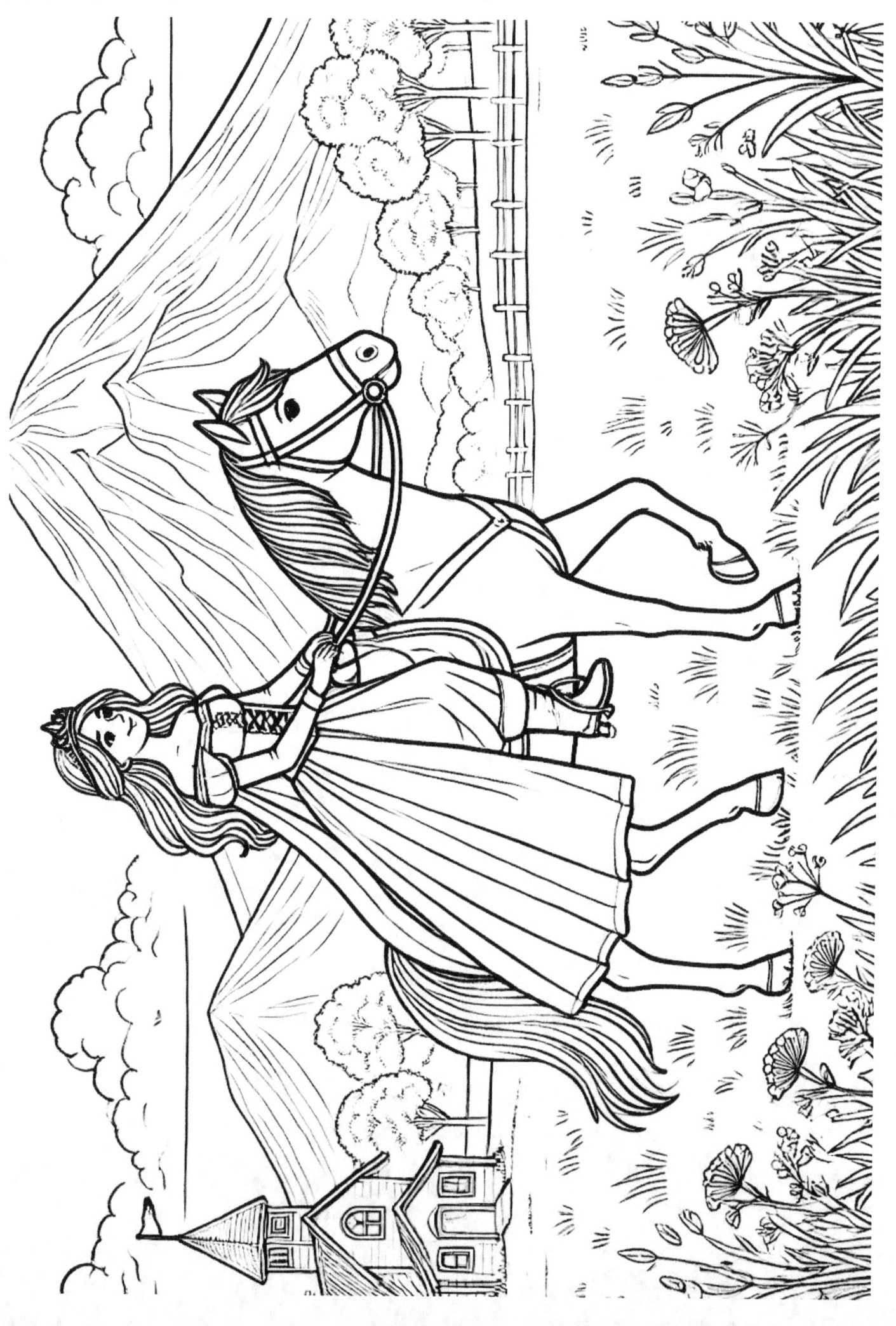

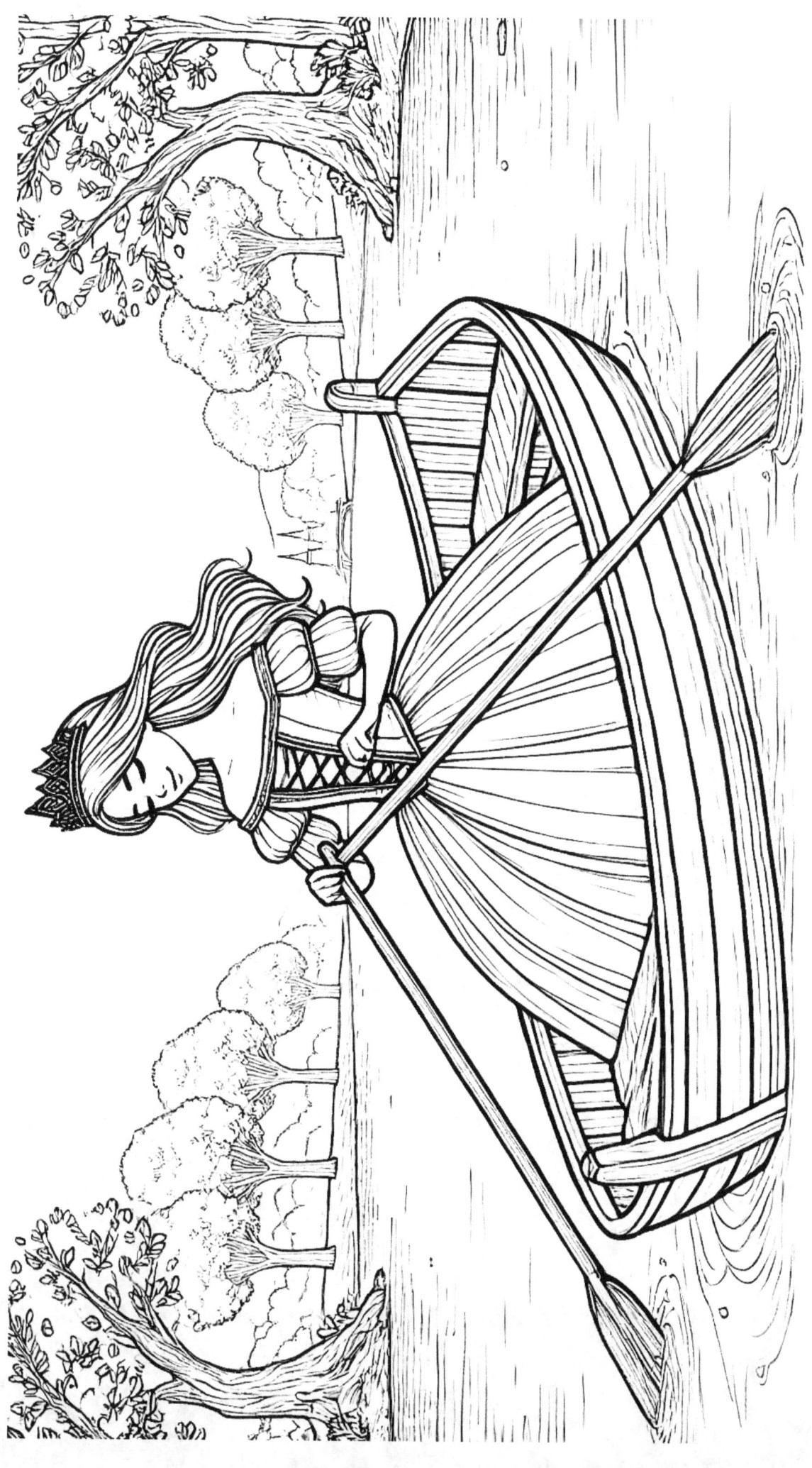

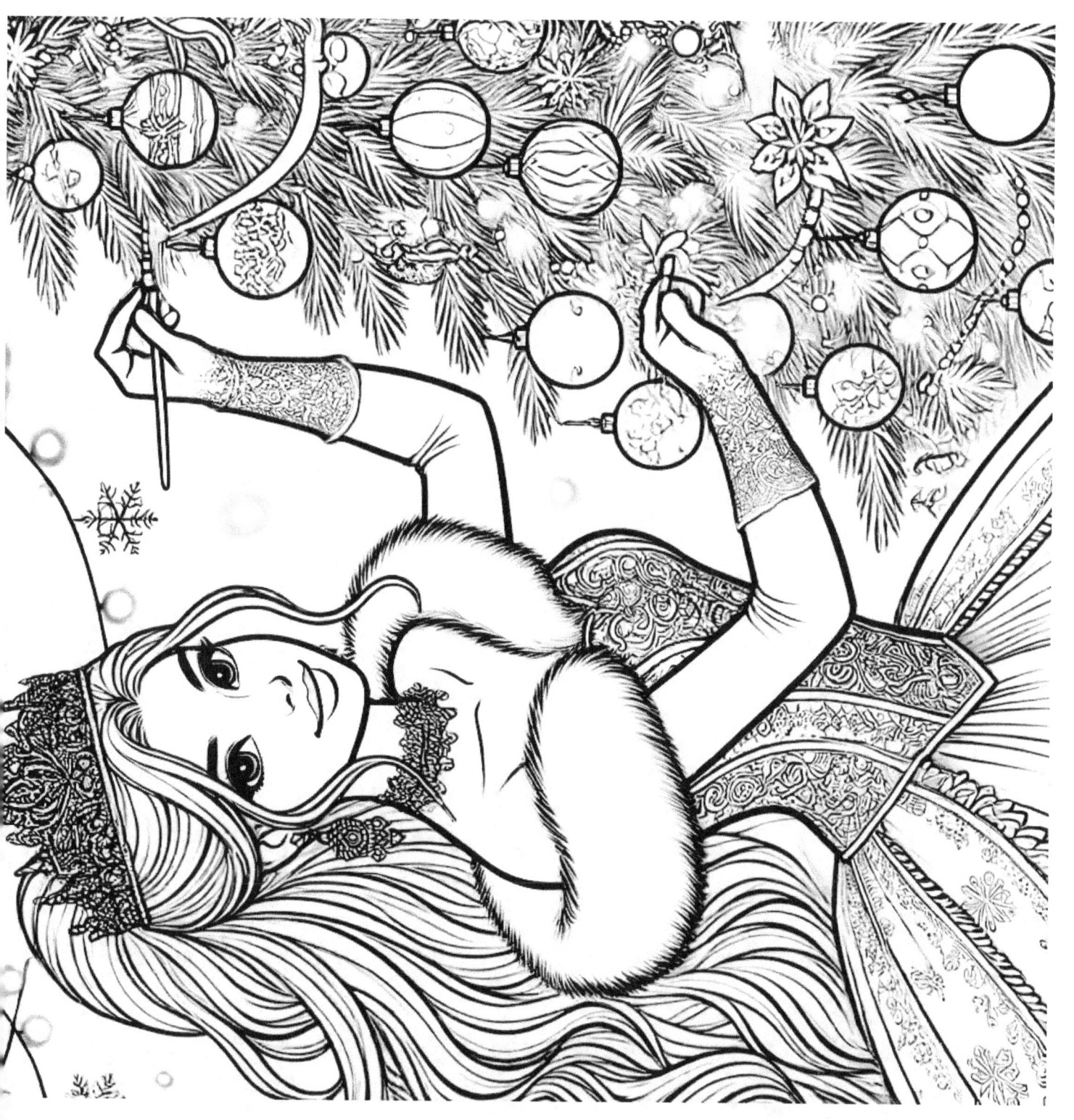

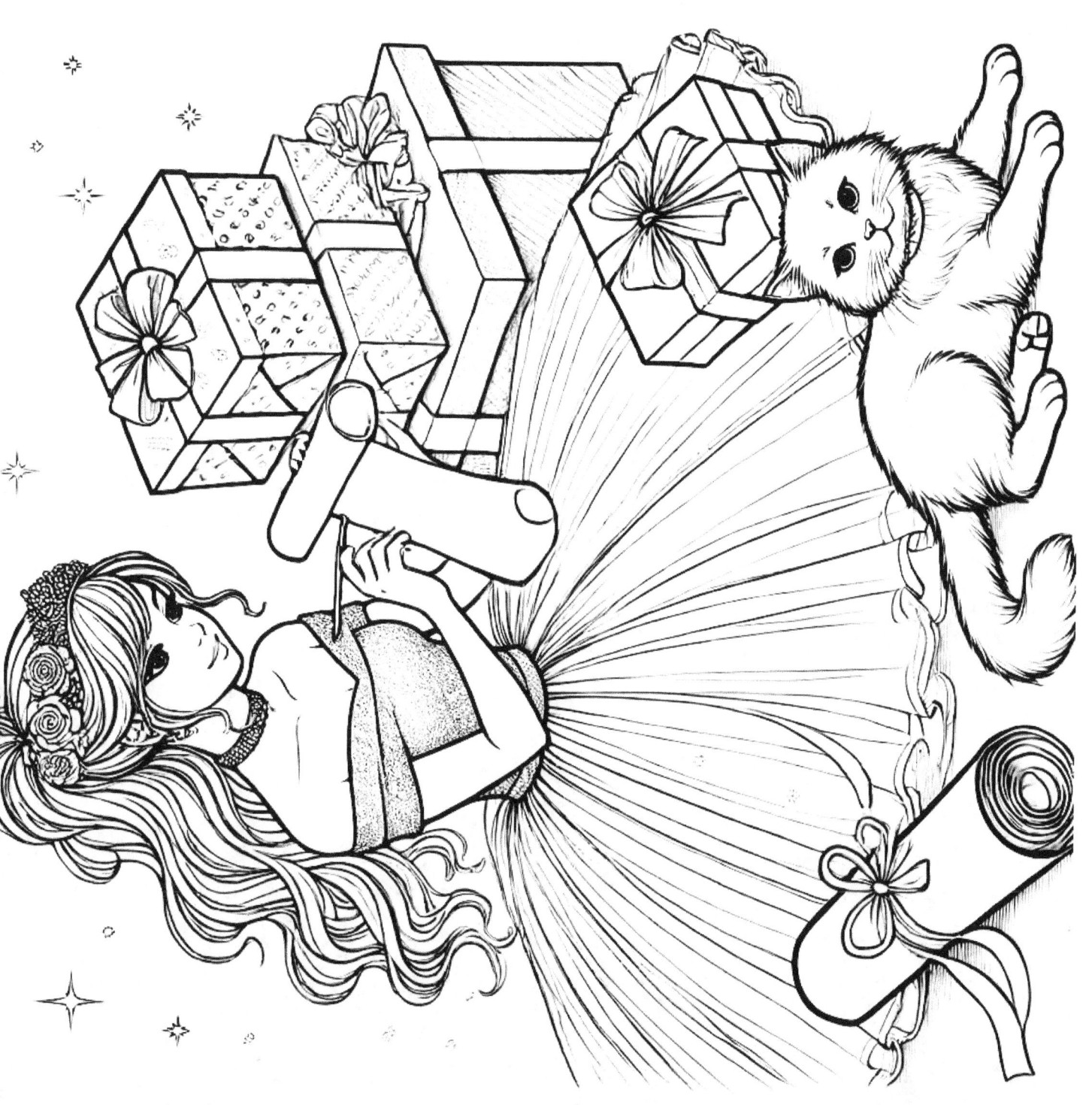

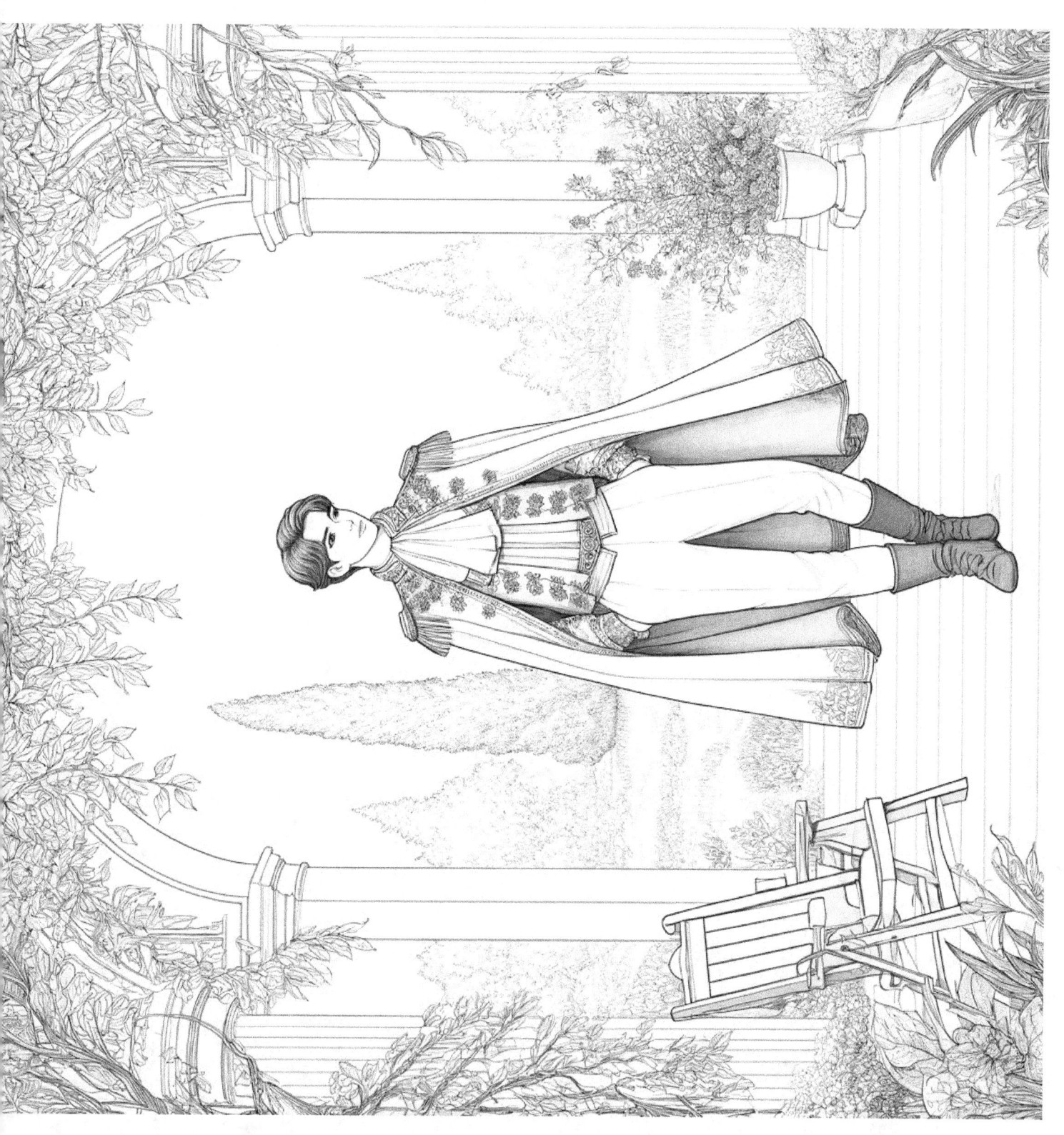

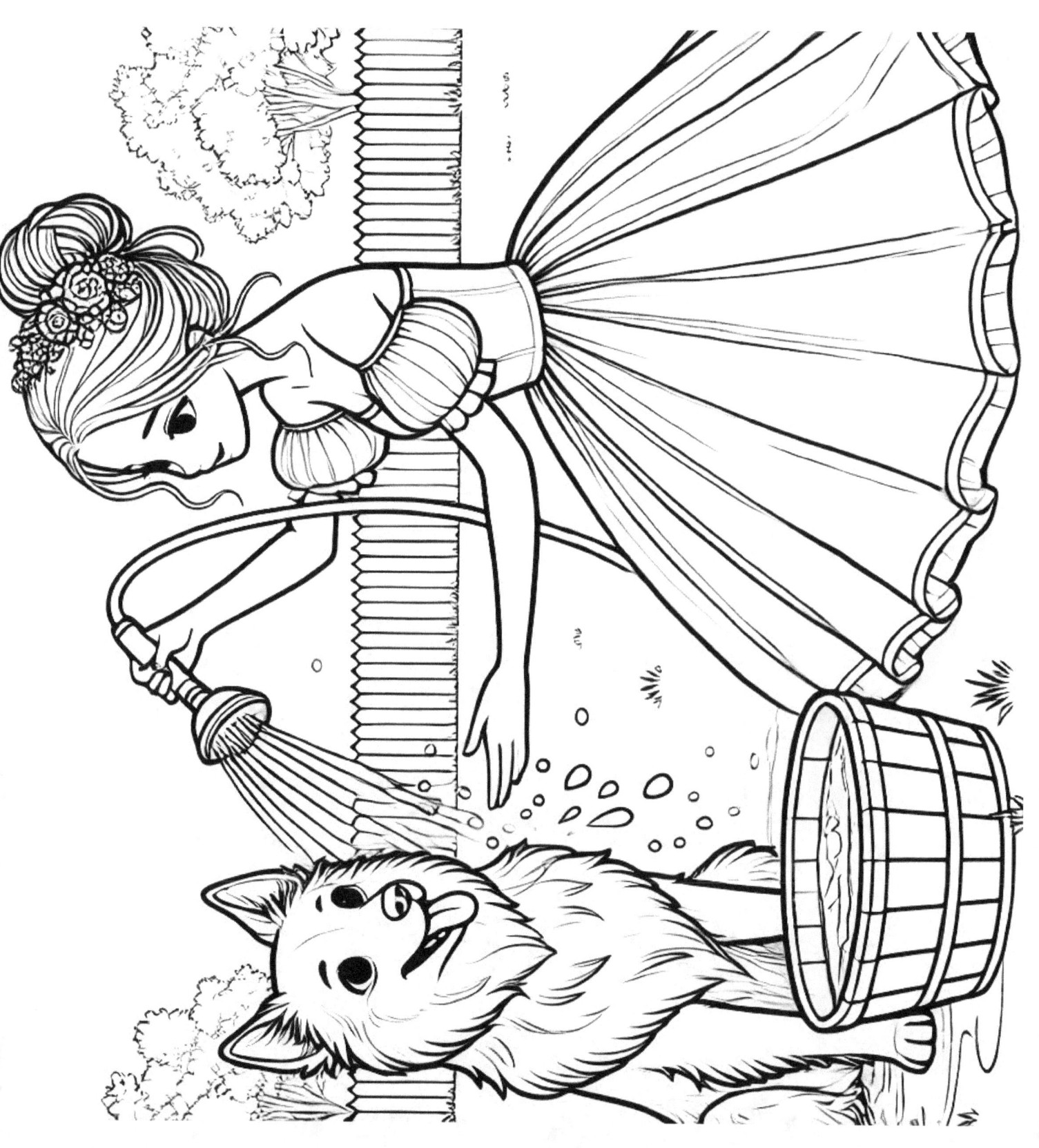

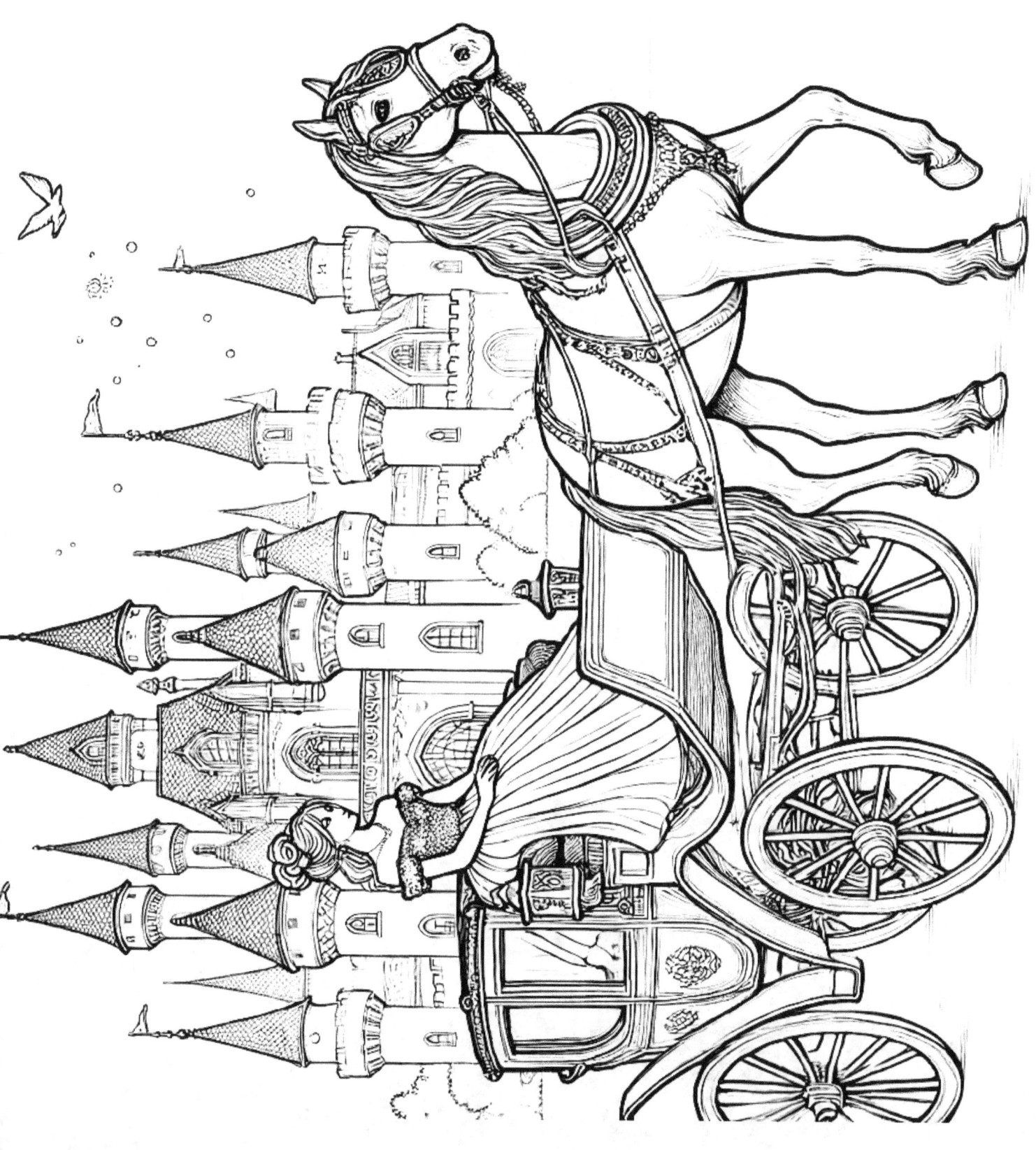

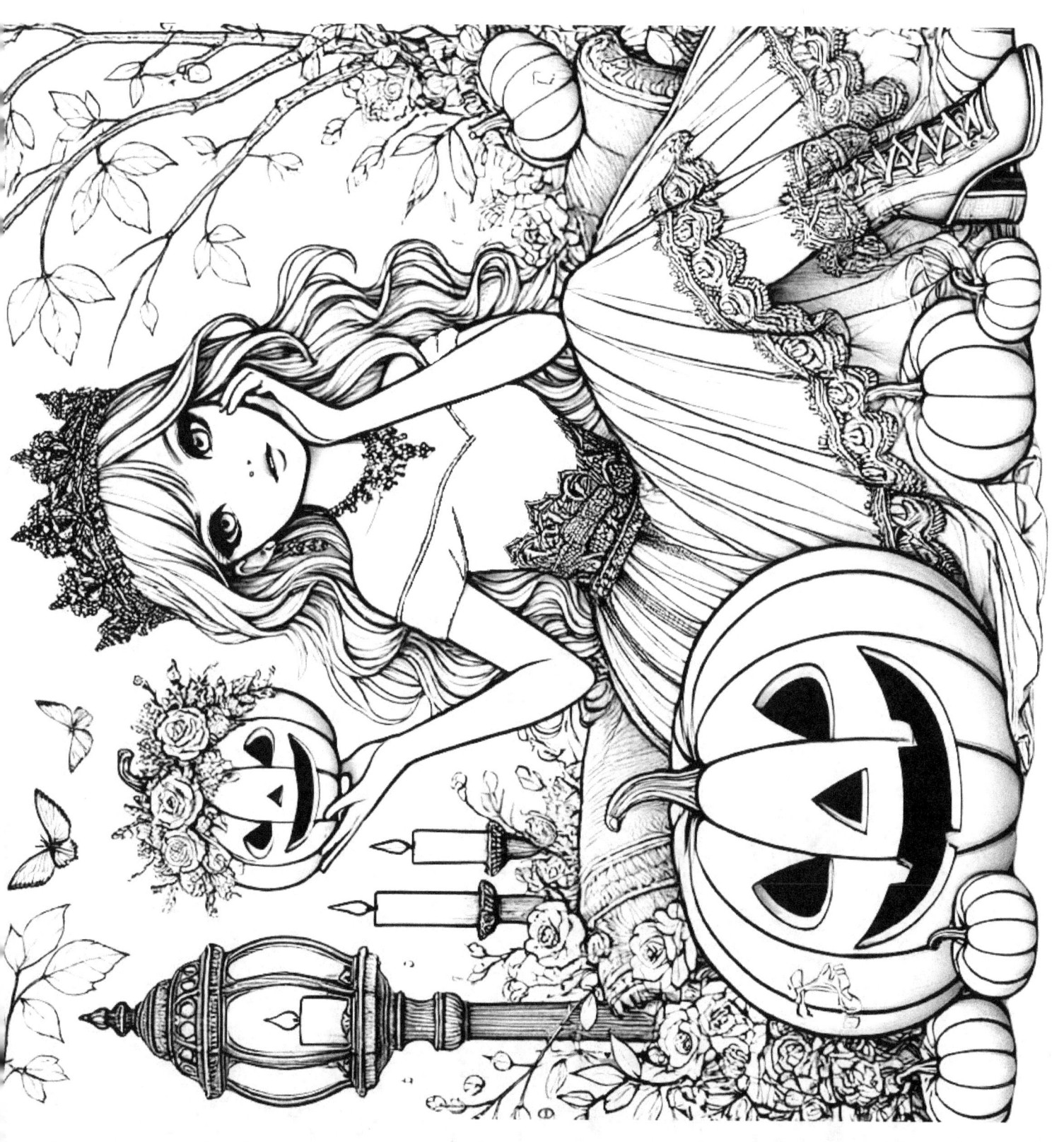

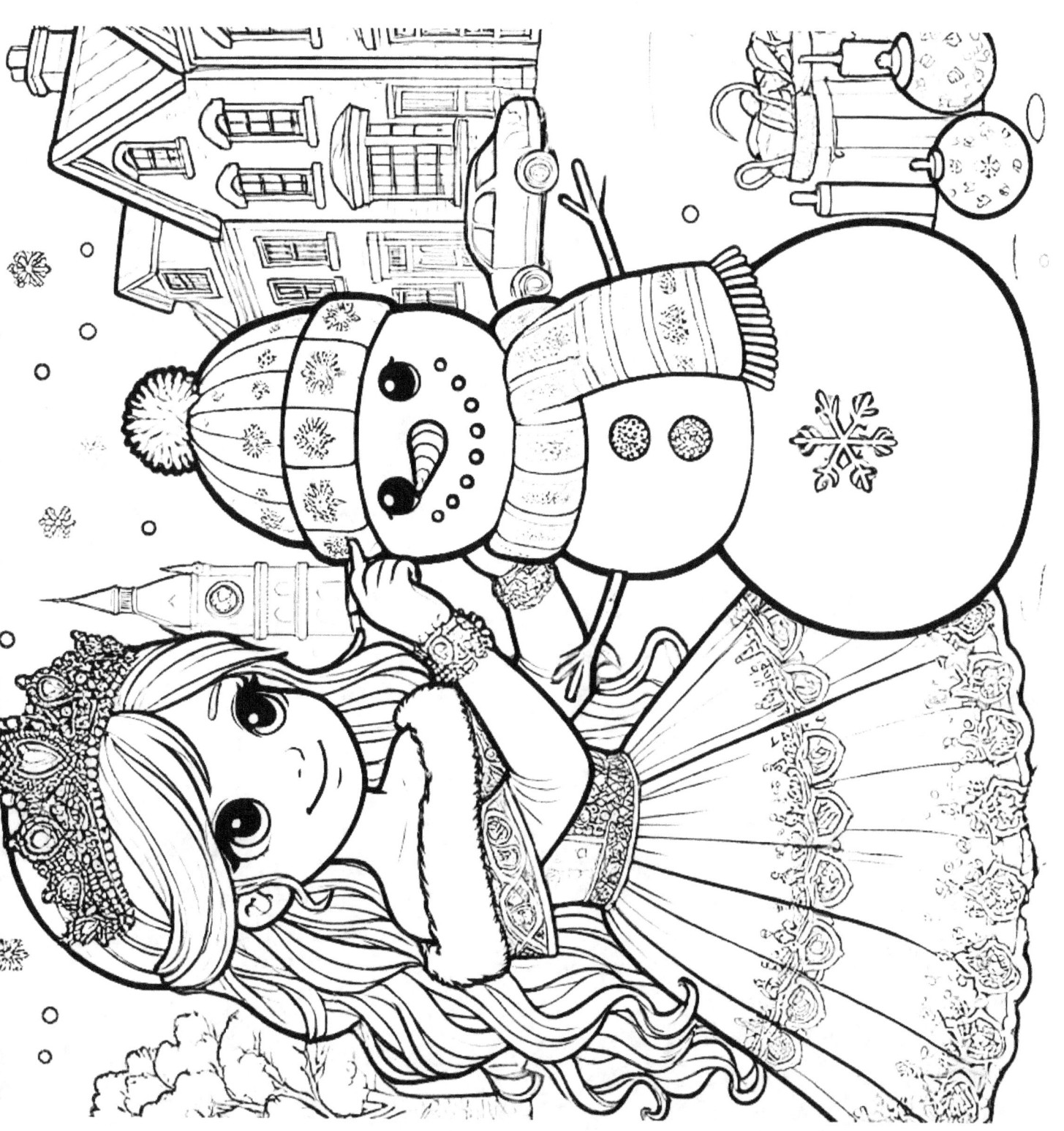

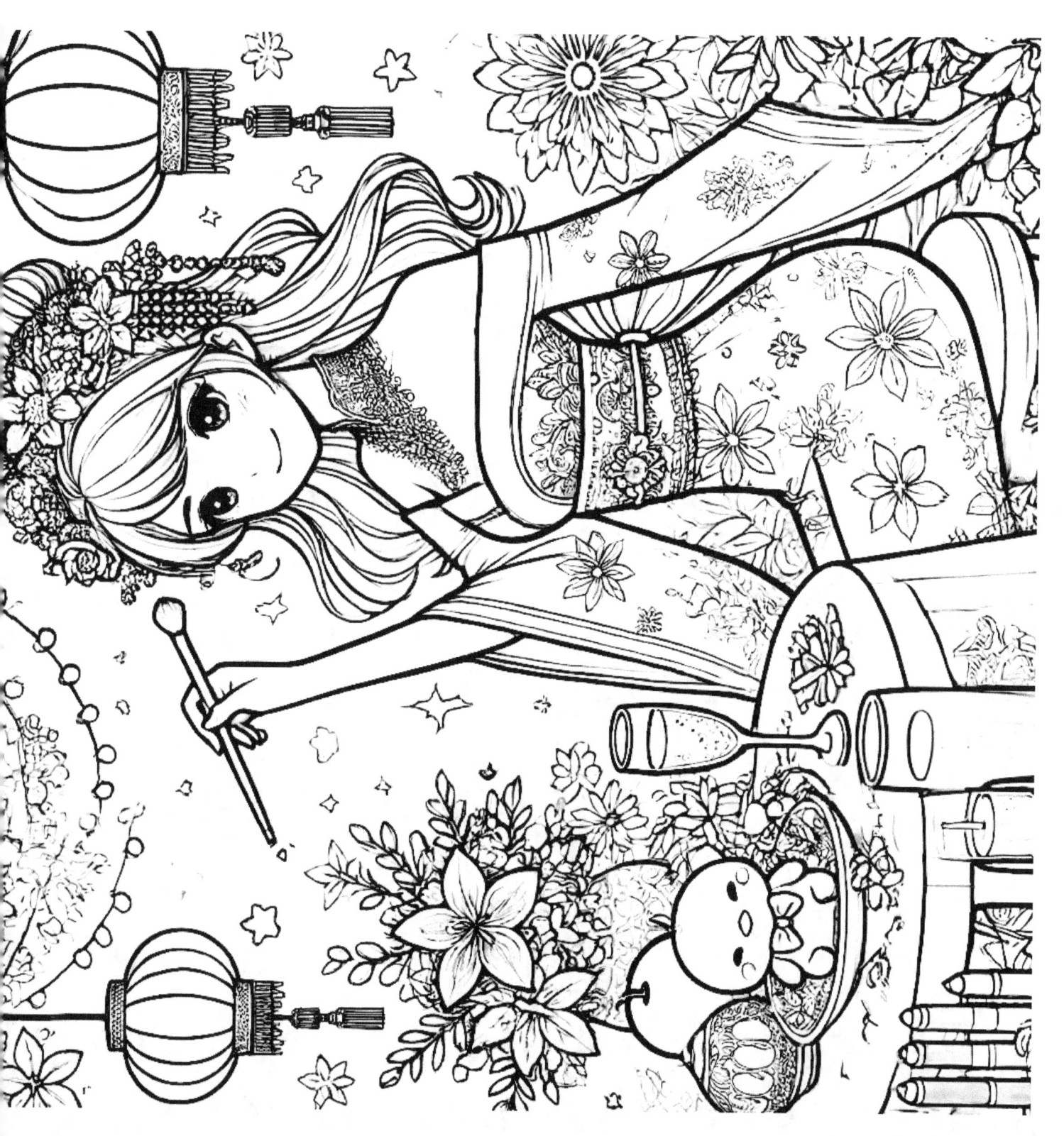

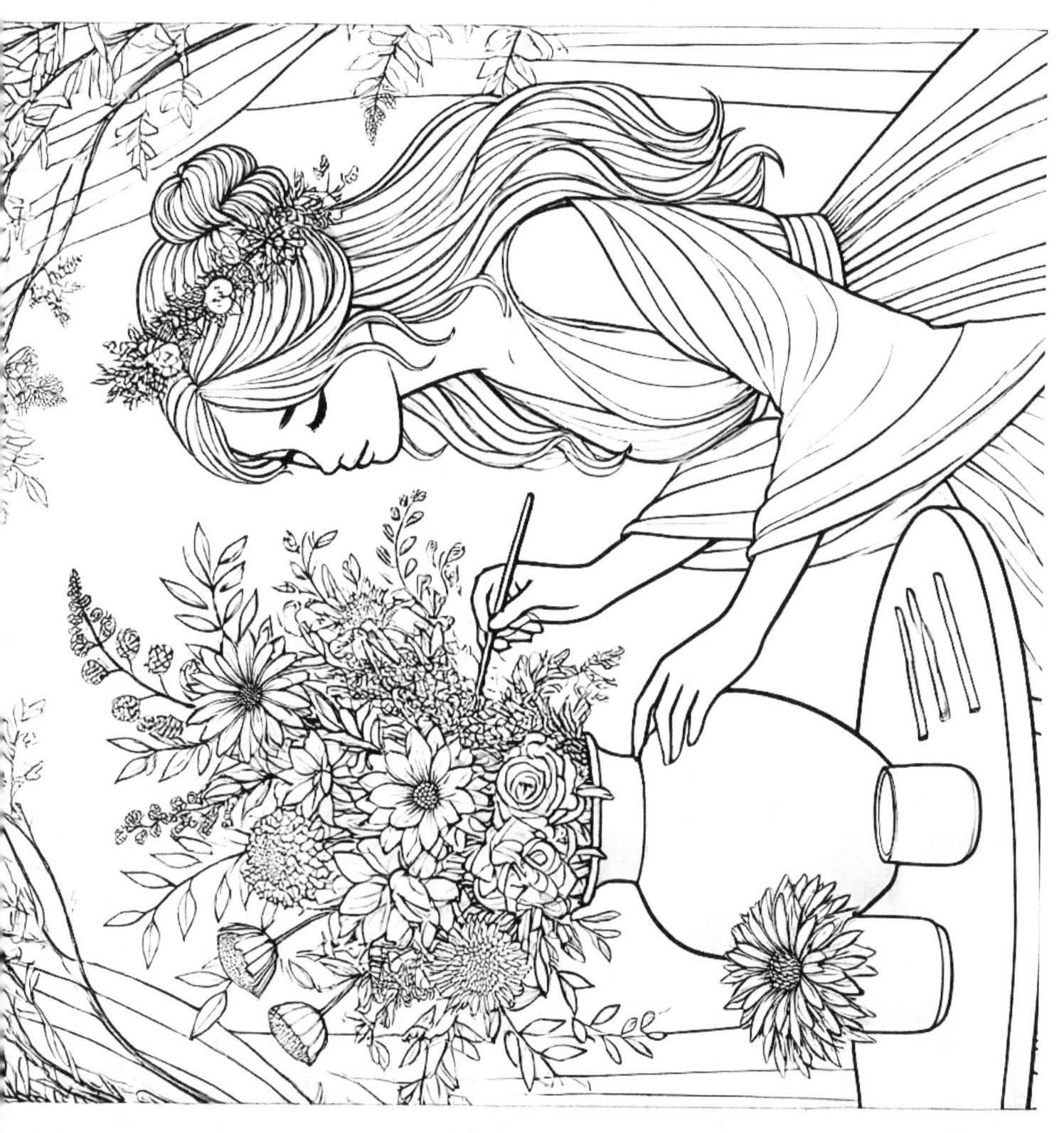

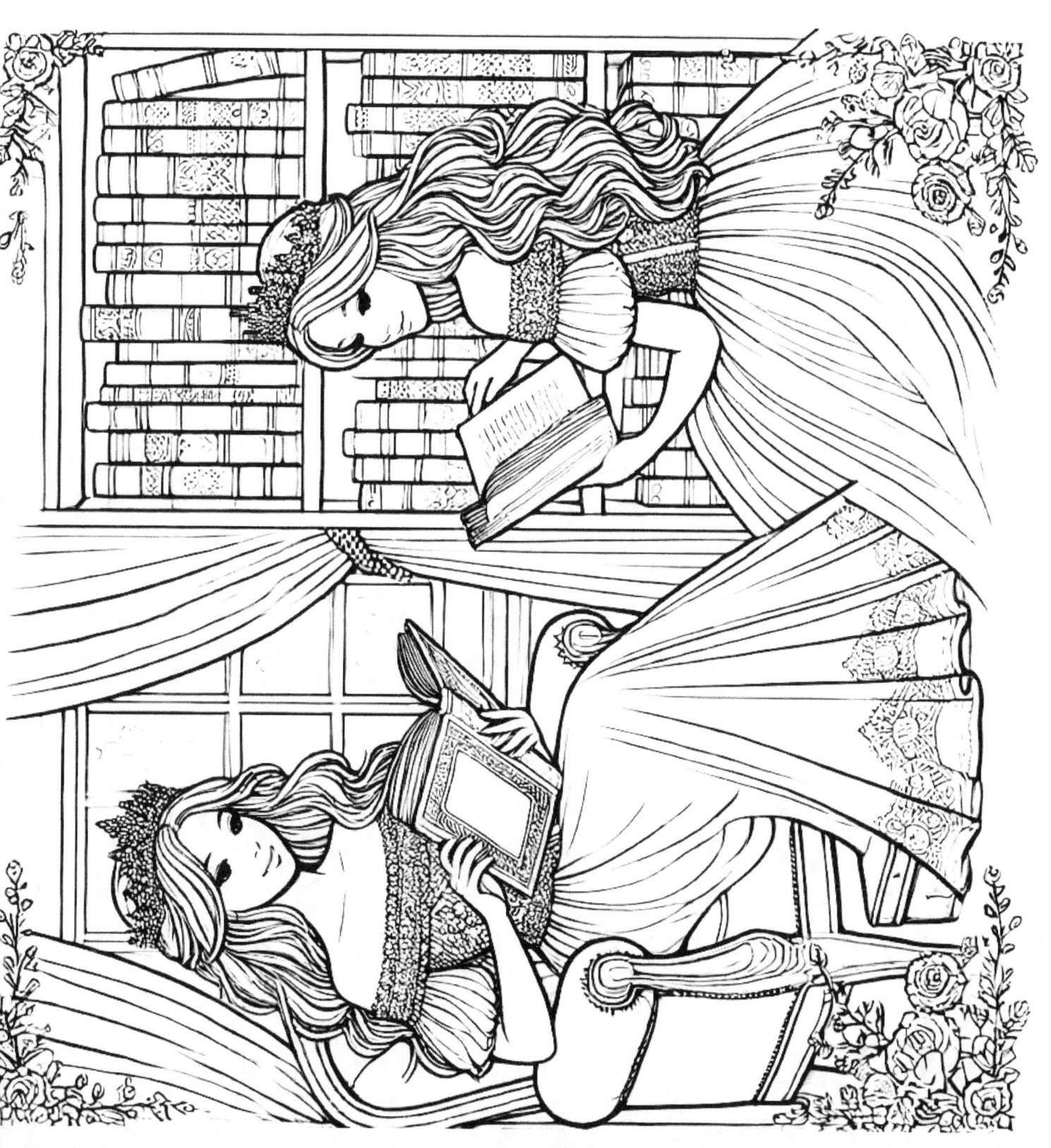

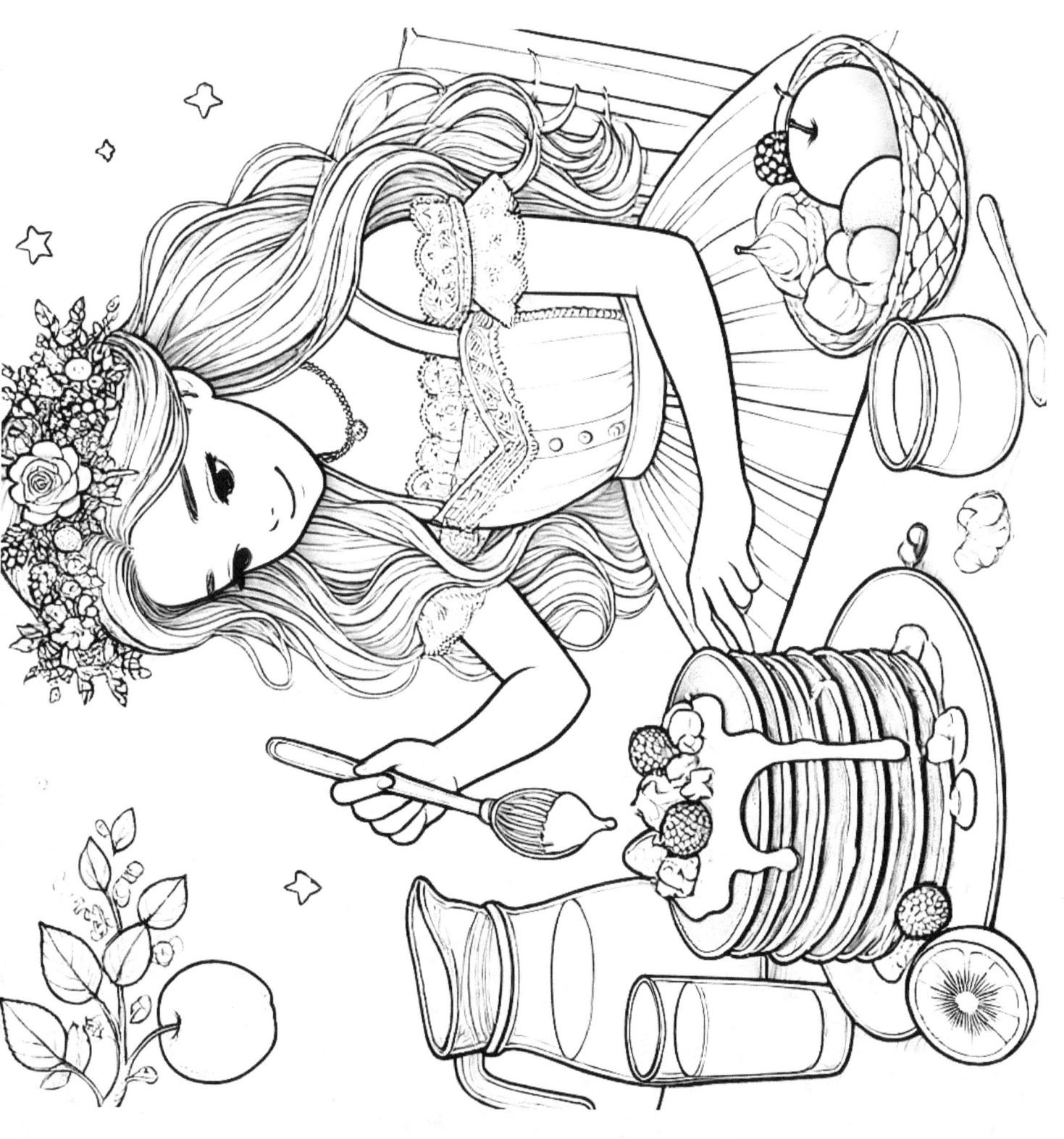

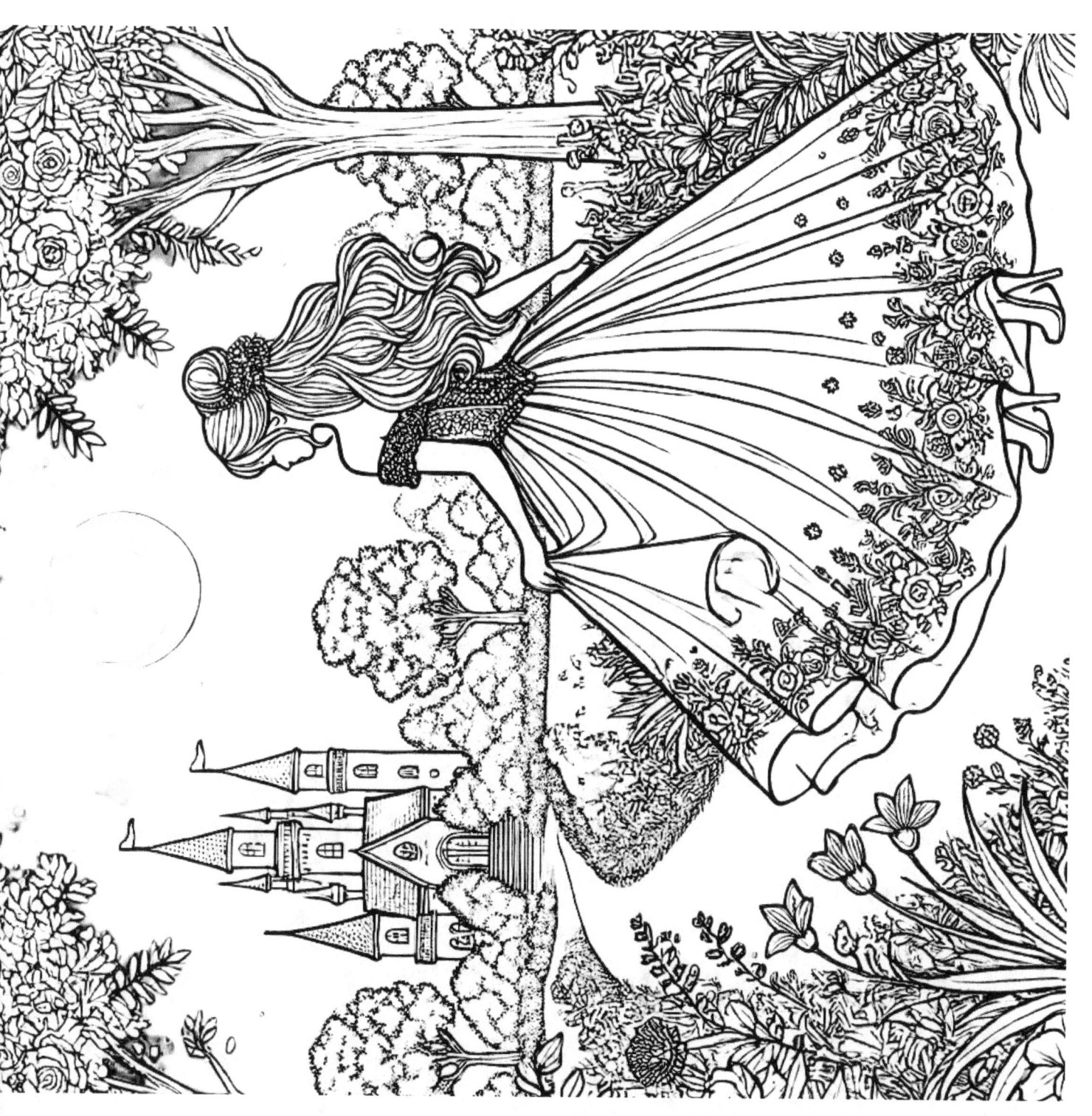

THANK YOU

www.ingramcontent.com/pod-product-compliance
Lightning Source LLC
Chambersburg PA
CBHW082237220526
45479CB00005B/1262